The Grolier
KidsCrafts

PUPPET
BOOK

Lyn Orton

Grolier Educational
Sherman Turnpike, Danbury, Connecticut

Published 1997 by Grolier Educational
Sherman Turnpike
Danbury, CT 06816

© 1993 Salamander Books Ltd.

Set ISBN: 0-7172-9090-5
Volume ISBN: 0-7172-9097-2

For information address the publisher:
Grolier Educational, Sherman Turnpike, Danbury, CT 06816

Library of Congress Cataloging-in-Publication Data

Orton, Lyn.
 [My puppet book]
 The Grolier kidscrafts puppet book / Lyn Orton.
 p. cm.
 Originally published under the title: My puppet book.
 Includes index.
 Summary: Provides instructions and patterns for making a variety of puppets,
from finger puppets, witches, animals, and clowns, as well as designs for stage sets.
 ISBN 0-7172-9097-2 (hardcover)
 1. Puppet making—Juvenile literature. [1. Puppet making. 2. Puppets.
3. Handicraft.] I. Grolier Educational (Firm) II. Title.
TT174.7.078 1997
75.592'24—dc21
 97-5697
 CIP
 AC

CREDITS
Commissioning editor: Veronica Ross
Art Director: Rachael Stone
Photographer: Jonathan Pollock
Assistant photographer: Peter Cassidy
Editor: Helen Stone
Designer: Cherry Randell
Theater designs by: Linda Barker and Barbara Simpson
Illustrators: John Hutchinson and Teri Gower
Character illustrator: Jo Gapper
Crafts inspector: Leslie Thompson
Diagram artist: Malcolm Porter
Typeset by: SX Composing DTP, Essex
Color separation by: P & W Graphics, Pte., Singapore
Printed in USA

CONTENTS

INTRODUCTION

Entertain your friends and family with your very own puppet show. In the *Puppet Book* there are a variety of colorful characters that are easy and fun to make – wicked witches and pretty fairies, cuddly cats and clever foxes, jolly clowns, and a spooky family of scary spiders. And why not make a stage set for your puppets too: there are two clever designs to choose from.

BEFORE YOU BEGIN

- Check with an adult before beginning any project; you might need some help.
- Read the instructions before you begin.
- Gather together everything you need first.
- Cover the work surface with an old cloth or newspaper.
- Protect your clothes with an apron or wear old clothes.

WHEN YOU HAVE FINISHED

- Put back the tops on glues and pens, wash paintbrushes and your hands.
- Put everything away. Store pens, paints, glue, etc in old ice cream containers or coffee cans.

SAFETY FIRST!

You will be able to make most of the projects in this book yourself but sometimes you will need help. Look out for the SAFETY TIP. It appears on those projects where you will need to ask an adult for help. However, sharp scissors, wire, or an oven are sometimes needed. Use common sense when using anything hot or sharp and ask an adult for help.

And please remember these basic rules of safety:

- Never leave scissors open or lying around where smaller children can reach them.
- Always stick needles and pins into a pin cushion or a scrap of cloth when you are not using them.
- Never use sharp scissors, wire, or an oven without the help or supervision of an adult.

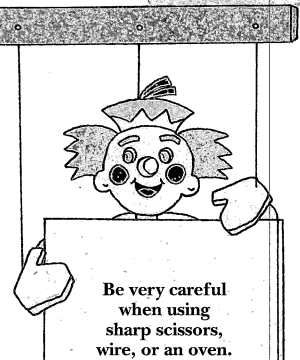

Be very careful when using sharp scissors, wire, or an oven.

MATERIALS AND EQUIPMENT

Every project will list all the things you need; for many of them you will simply need to hunt around the house, but check with an adult before taking anything. Some items, such as pompons, jumbo pipe cleaners, and joggle eyes will need to be bought from a craft supplier or large department store. However, if you have trouble finding these items, think of ways in which you can improvise: scraps of felt can be turned into eyes, and pompons can be made from yarn. Pressed paper balls or eggs can also be bought from craft shops but you can make your own from papier mâché pulp.

USING PATTERNS

At the back of the book you will find the patterns you will need for some of the projects. Using a pencil, trace the pattern you need. If you are making a puppet from fabric, cut the pattern out and pin it on the fabric. Cut out the shape. If you want to cut the pattern out of cardboard, turn your tracing over and rub firmly over the pattern outline with a pencil. The pattern will transfer onto the board. Cut out this shape. Once you have gained confidence making some of the puppets, why not try creating your own characters?

Get everything ready before you start, and don't forget to clean up afterward!

GROWN UPS TAKE NOTE

Every project in the *Puppet Book* has been designed with simplicity, yet effectiveness, in mind. However, occasionally sharp scissors or an oven may be needed. Your involvement will depend on the age and ability of the child, but we recommend you read through each project before it is undertaken.

It is also worth pointing out that some of the puppets are not suitable for very young children to play with. The small parts used in making some of the puppets, such as beads or pieces of wire, could easily become loose and choke or injure a small child.

Remember to check with an adult before you begin any project; you may need some help.

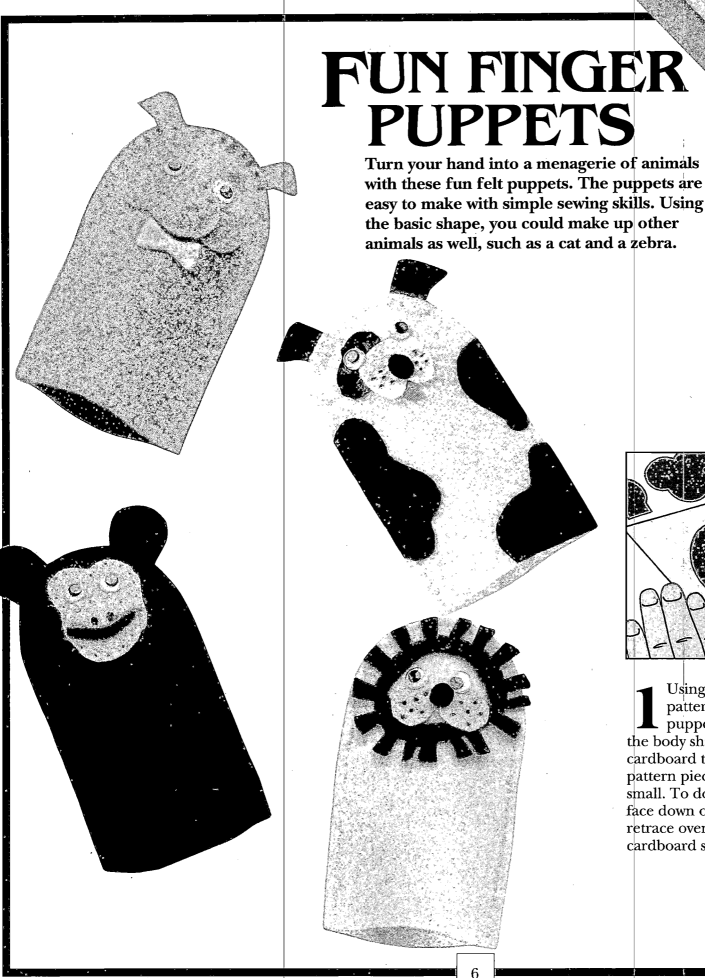

FUN FINGER PUPPETS

Turn your hand into a menagerie of animals with these fun felt puppets. The puppets are easy to make with simple sewing skills. Using the basic shape, you could make up other animals as well, such as a cat and a zebra.

1 Using a pencil, trace all the pattern pieces for one of the puppets on page 36. Cut out the body shape. You'll need to make cardboard templates of the other pattern pieces because they're so small. To do this, turn your tracing face down onto the white board and retrace over the outlines. Cut out the cardboard shapes.

YOU WILL NEED
Scraps of felt in brown,
 white, pink, yellow, and beige
Small joggle eyes
Small black pompons
Tracing paper and pencil
Black felt-tip pen
Ball-point pen
White cardboard and scissors
Needle, pins and thread
Tailor's chalk
All-purpose glue

2 Pin the body pattern onto two layers of colored felt and cut out the shape. Now draw around the board templates onto the correct colored felt using a ball-point pen (or tailor's chalk on dark colors.) You'll need to draw two ears for the pig, monkey, and dog, and two cheeks for the lion and pig. Cut out the shapes.

3 Now sew or glue all the features, such as the snout, mouth, eyes, and mane etc. onto one of the felt bodies. Leave the ears until the next stage. Then use a felt-tip pen to add the dots to the dog's and lion's face, and to make the monkey's nostrils.

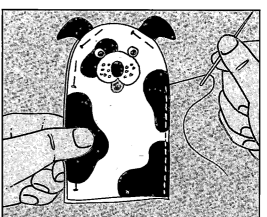

4 Pin the two body pieces together, right side out, slipping the base of the ears into place between the layers as you go. Finish off by neatly sewing all around, close to the edge. Leave the bottom edge open.

TALKING FOX

If you're good at sewing, you'll enjoy making this foxy glove puppet. He's quite complicated, so follow the instructions carefully. When you've made him, work his jaws with your fingers and thumb to make him talk.

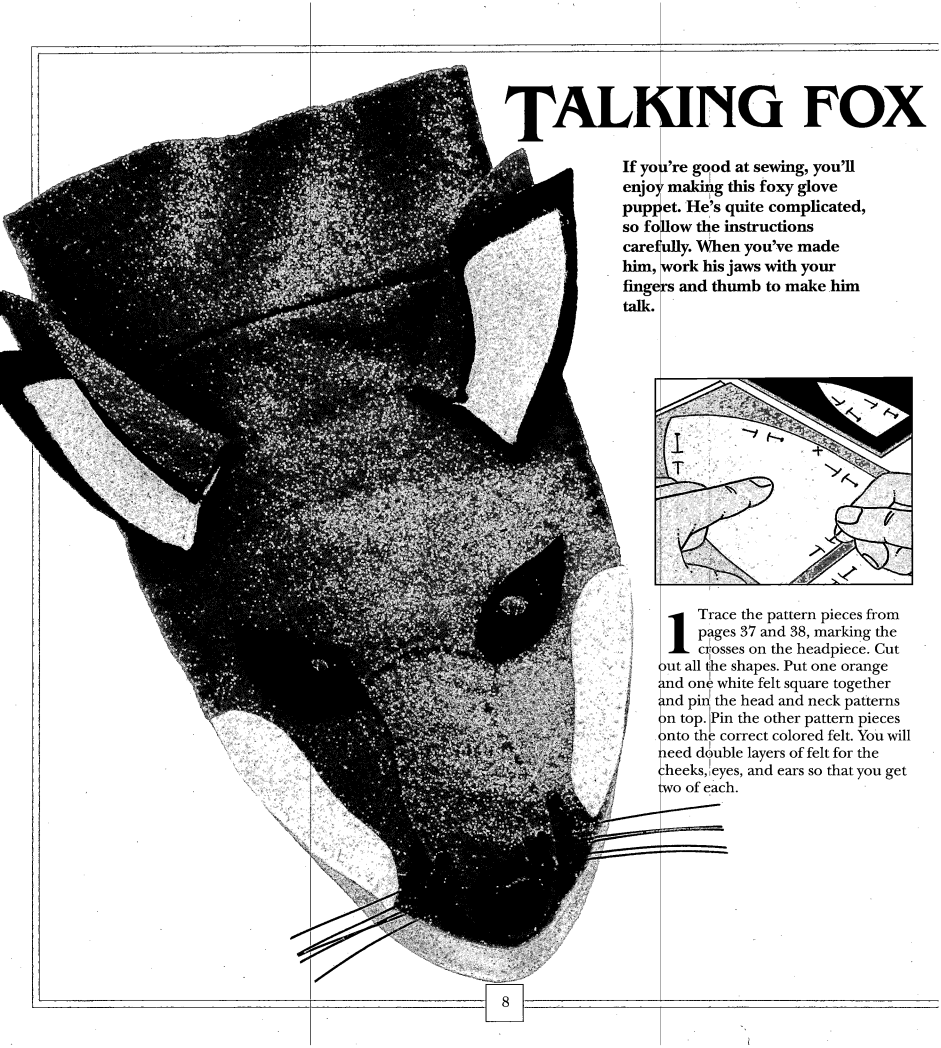

1 Trace the pattern pieces from pages 37 and 38, marking the crosses on the headpiece. Cut out all the shapes. Put one orange and one white felt square together and pin the head and neck patterns on top. Pin the other pattern pieces onto the correct colored felt. You will need double layers of felt for the cheeks, eyes, and ears so that you get two of each.

YOU WILL NEED

2 squares of orange felt
2 squares of white felt
1 square of beige felt
Scraps of black and brown felt
Pair of plastic eyes
Plastic nose (or modeling clay)
Plastic whiskers (or broom bristles)
10 tiny black pompons
Needle, pins, and scissors
Orange and white thread
Tracing paper and pencil
Black felt-tip pen

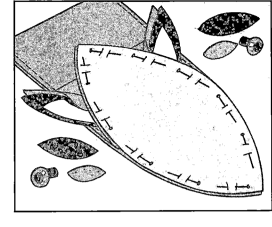

3 Glue the whiskers onto the orange head. Then pin the snout in place, covering the ends of the whiskers. Neatly sew the snout to the head. Place the three layers of ears together as shown.

5 Open out the mouth end and pin the beige mouth piece in place. Neatly sew all around, close to the edge. To finish, glue the outer and inner eyes in place and stick the plastic eyes on top. Stick the nose in position and add tiny black pompons around the whiskers.

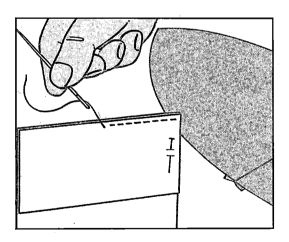

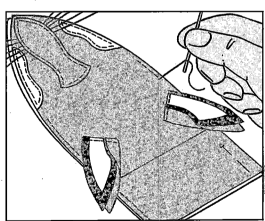

2 Cut out all your felt shapes. Place the long straight edges of the orange head and neck together, and pin. Sew them together neatly about ¼ inch from the edge. Repeat for the white head and neck. Open out the head and neck pieces.

4 Sew the ears in place, folding the inner corners over as shown. Sew the cheeks in place. Place the orange and white heads together, with the neck seams facing in. Following the marks on your pattern, pin the heads together from the crosses to the straight edge. Sew neatly together.

JOEY THE CLOWN

Test your sewing skills with this colorful clown glove puppet. He's quite complicated to make, so follow the instructions carefully. You work him by putting your hand through a slit in the back of his body.

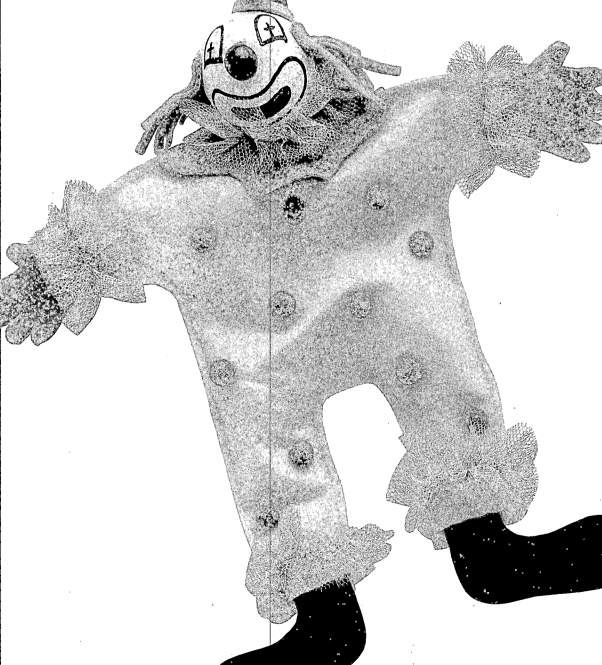

1 Trace the pattern pieces from page 39, and cut out all the shapes. Place the two squares of yellow felt together and pin the body pattern on top. Cut out, then cut a slit in one of the body pieces as marked on the pattern.

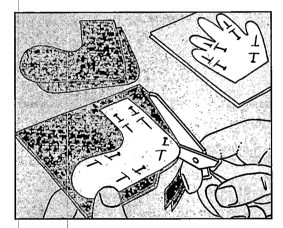

2 Pin the collar pattern onto a piece of green felt and cut out. Pin the hand and hair patterns onto two layers of blue felt and the foot onto two layers of red. Cut out the shapes. Then cut out two more feet and hands.

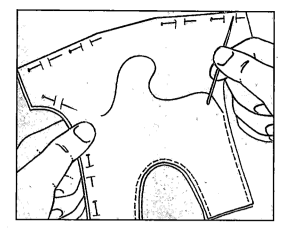

3 Pin the two body pieces together. Sew around the edges, leaving the neck, wrists and ankles open. Now sew the hands together in pairs. Glue two felt feet side by side onto white cardboard and cut them out. Cover the back of each foot with a red felt foot.

5 Tuck the ends of the hands and feet into the wrist and ankle openings. Glue in place. Draw a face on the ball using felt-tip pens, and stick on the red nose. Cut a fringe in the two blue hair pieces, and glue both layers to the back of the head. Glue the head into the neck opening and secure with sticky tape.

6 Wrap the felt collar around the neck. Gather the green net around the neck as before, and sew the collar and frill in place at the back. Finally, stick the hat on the head and decorate the clown with pompons. (To make your own hat, cut out a half circle of red card, 2 inches across. Wrap it into a cone shape and stick together.)

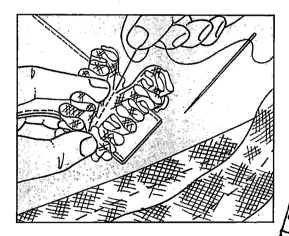

4 For the frills, cut the green net into five strips, 14 inches × 1½ inches. Run a line of stitching down the middle of one strip. Without removing the needle, gather the net around one of the wrists and sew in place. Repeat for the other wrist and the ankles.

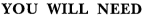

YOU WILL NEED

2 squares of yellow felt
1 square of blue felt
Scraps of red and green felt
Pressed paper ball, 2 inches
 across
Green net and red
 nose (or bead)
Clown hat (from craft
 shop) or red cardboard
Black and red felt-tip pens
Tracing paper
 and pencil
White cardboard
Needle and pins
Yellow thread
Scissors and scotch tape
All-purpose glue
12 pink and 1 green
 pompon

RAGING BULL

Stage your own festival with this fiery Chinese-style puppet. Slip your arms through the armbands and, holding the head in front of your own, dance behind the flowing body. We've used double-sided crêpe paper, but ordinary crêpe paper works just as well.

1 Using a soft pencil, trace all the pattern shapes from pages 40 and 41. We have only given you half of the head pattern because it is so big. When you have traced it once, turn your tracing paper over and trace the shape again to complete it.

2 Turn the nose tracing face down onto some yellow crêpe paper and retrace over the outline. The shape will appear on the paper; cut this out. Cut the smaller shapes out of different colored paper. You will need to cut two of some shapes.

3 Retrace over the head shape onto blue board turning your trace over as before to complete the shape. Cut the head out. Cut the eye holes out as marked. Now glue all the crêpe paper shapes onto the head, following the main picture.

YOU WILL NEED
12 inch square of dark
 blue cardboard
Length of double-sided blue and
 purple crêpe paper,
 4 feet × 10 inches
Scraps of different colored
 crêpe paper
Tracing paper and soft pencil
All-purpose glue
Scissors

4 Glue the head onto one end of the long strip of double-sided blue and purple crêpe paper. This forms the "body" of your puppet. Cut small strips of colored crêpe paper 10 inches × 2 inches, and glue them onto the body.

5 For the arm bands, cut long strips of pink crêpe paper 24 inches × 2 inches. Fold the strips in half and stick them onto the back of the body to form loops on either side.

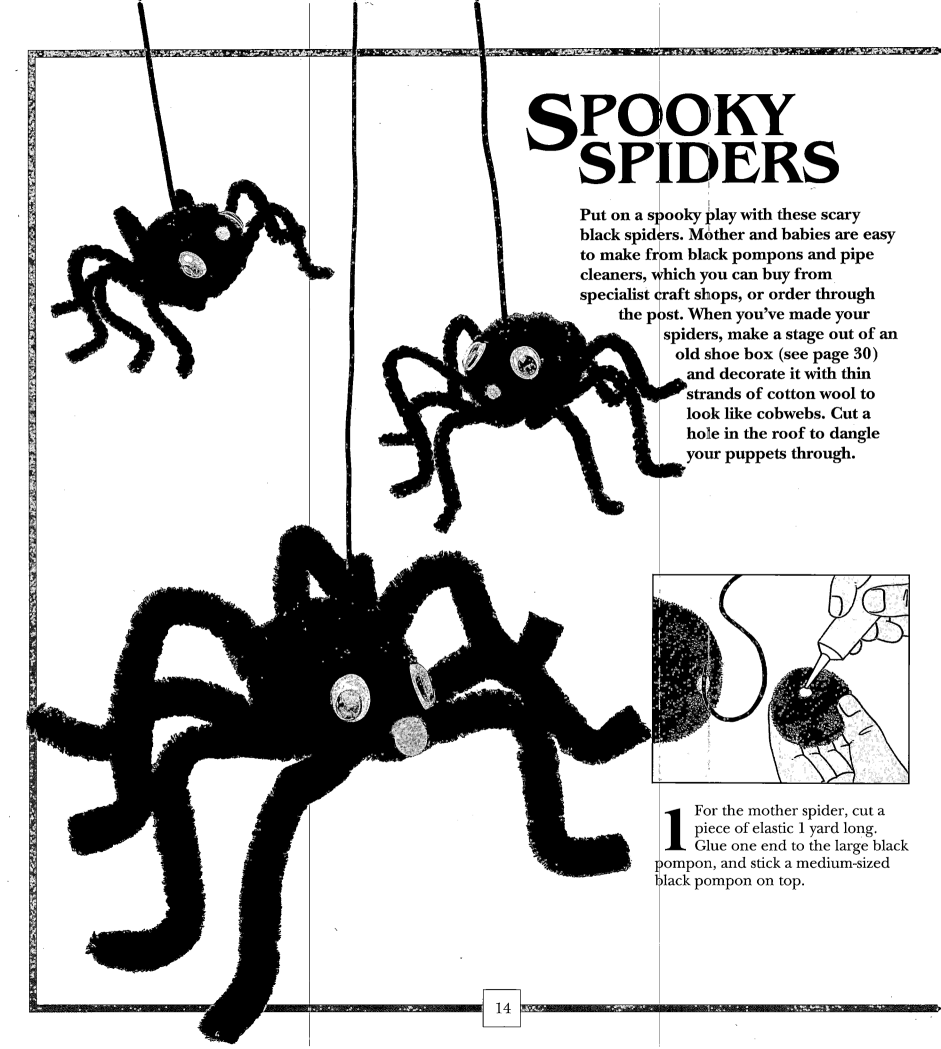

SPOOKY SPIDERS

Put on a spooky play with these scary black spiders. Mother and babies are easy to make from black pompons and pipe cleaners, which you can buy from specialist craft shops, or order through the post. When you've made your spiders, make a stage out of an old shoe box (see page 30) and decorate it with thin strands of cotton wool to look like cobwebs. Cut a hole in the roof to dangle your puppets through.

1 For the mother spider, cut a piece of elastic 1 yard long. Glue one end to the large black pompon, and stick a medium-sized black pompon on top.

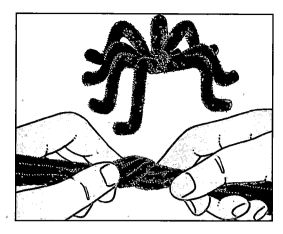

2 To make the legs, twist the four jumbo pipe cleaners together in the middle and spread the ends out to make a star shape. Bend each "leg" into shape at the knees and ankles.

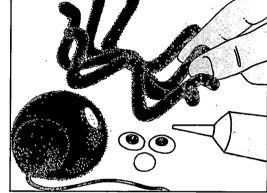

3 Glue the legs onto the bottom of the spider's body. Finally, glue the large joggle eyes onto the head and stick the large yellow pompon in place for the nose.

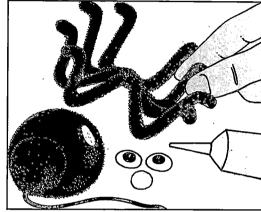

4 Make the baby spiders in the same way, using the medium-sized and small black pompons. Decorate the head with the small joggle eyes and tiny yellow pompons.

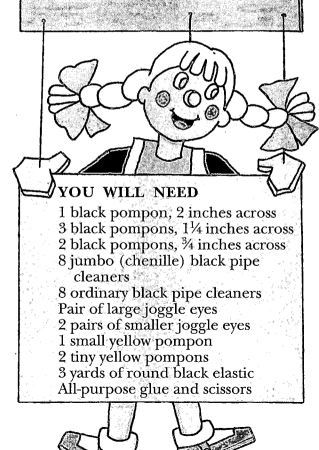

YOU WILL NEED

1 black pompon, 2 inches across
3 black pompons, 1¼ inches across
2 black pompons, ¾ inches across
8 jumbo (chenille) black pipe cleaners
8 ordinary black pipe cleaners
Pair of large joggle eyes
2 pairs of smaller joggle eyes
1 small yellow pompon
2 tiny yellow pompons
3 yards of round black elastic
All-purpose glue and scissors

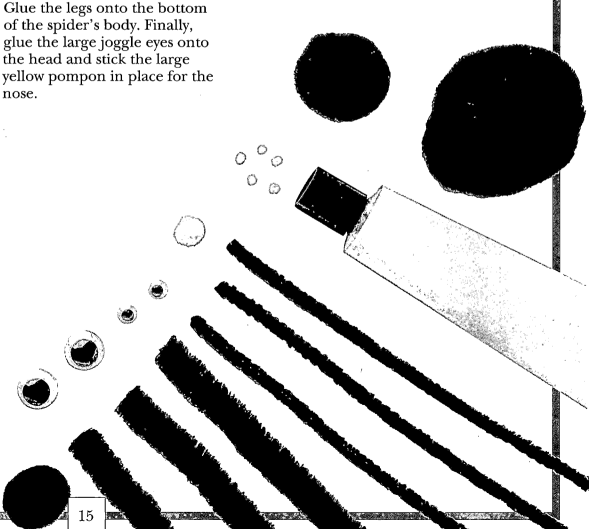

KING OF THE BEASTS

You become the puppet when you slip this fabulous lion hood over your head. He's easy to make from colored crêpe paper. You can either use double-sided crêpe paper, which is a different color on each side, or you can use ordinary crêpe paper cut to size.

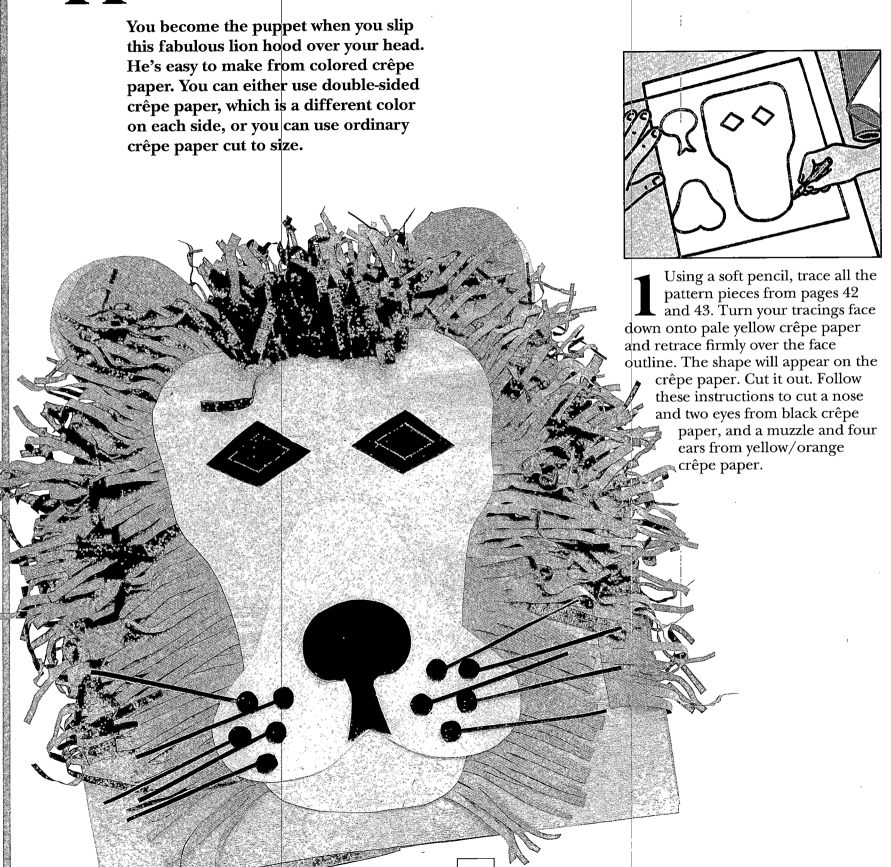

1 Using a soft pencil, trace all the pattern pieces from pages 42 and 43. Turn your tracings face down onto pale yellow crêpe paper and retrace firmly over the face outline. The shape will appear on the crêpe paper. Cut it out. Follow these instructions to cut a nose and two eyes from black crêpe paper, and a muzzle and four ears from yellow/orange crêpe paper.

2 Cut two squares of yellow/orange crêpe paper, 15 inches × 15 inches. If your paper is not wide enough, simply stick two pieces together with clear tape. Place both squares together, then cut one end into a curved shape as shown.

3 Stick a pair of ears down onto one of the hood pieces, then glue a second pair of ears on top. Spread glue around the edge of the hood, and stick the other hood piece on top. Leave the bottom edge unstuck. When the glue is dry, try the hood on and ask a friend to mark where the eyes should be.

5 Glue strips of mane around the back of the face piece (except the chin) and stick the face onto the mask. Glue the muzzle on top, and then the nose. Glue the eyes in the places marked and cut out the centers. Finally, cut circles of black crêpe paper and narrow strips of black cardboard to make the whiskers. Glue in place.

YOU WILL NEED

Double-sided yellow and
 orange crêpe paper
Double-sided orange
 and red crêpe paper
Pale yellow crêpe paper
Black crêpe paper
Tracing paper and soft pencil
All-purpose glue
Clear tape
Black cardboard
Scissors

4 To make the mane, cut the red/orange crêpe paper into long strips, 4½ inches wide. Cut a fringe into the strips as shown. Now glue the mane around the edge of the mask. Gently curl the fringe by pulling it across a pencil.

SPOT THAT PIG!

Make this cheerful piggy glove puppet from brightly colored felt. It's very easy and needs only the simplest sewing skills. Once you've made it, try making other animals from the basic body shape and put on a farmyard show.

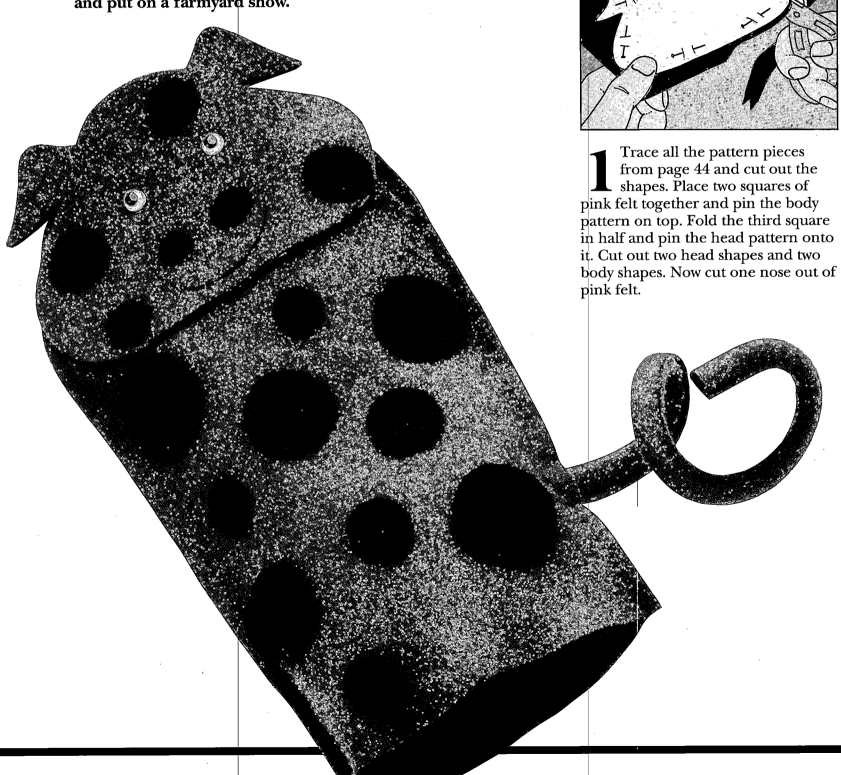

1 Trace all the pattern pieces from page 44 and cut out the shapes. Place two squares of pink felt together and pin the body pattern on top. Fold the third square in half and pin the head pattern onto it. Cut out two head shapes and two body shapes. Now cut one nose out of pink felt.

2 For the tail, cut a strip of pink felt 8 inches × ¾ inches. Fold it in half lengthwise and pin together. Neatly sew across one end and along the full length, close to the edge. Now push the pipe cleaner into the tube, trimming the end if necessary.

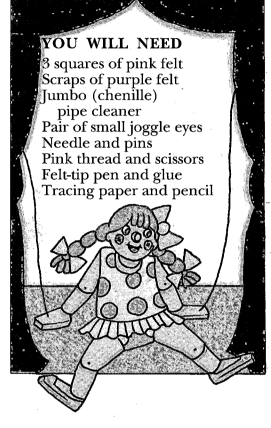

YOU WILL NEED

3 squares of pink felt
Scraps of purple felt
Jumbo (chenille)
 pipe cleaner
Pair of small joggle eyes
Needle and pins
Pink thread and scissors
Felt-tip pen and glue
Tracing paper and pencil

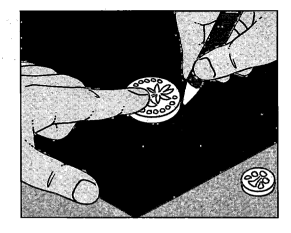

5 Finally, make some felt circles to decorate your puppet. To do this, simply draw around some coins onto the purple felt using a felt-tip pen. Cut the circles out and stick them onto the head and body. Cut two smaller circles for the nostrils.

3 Put the two body shapes together, slipping the open end of the tail into position between the two layers, as shown. Pin the body pieces together. Now sew all around, close to the edge. Leave the bottom edge open.

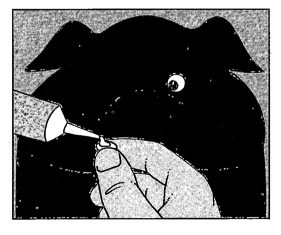

4 Glue the two head shapes together, then stick the head onto the body. Stick the pink nose and the joggle eyes in place.

SPRING CHICK

Entertain your friends with an Easter play, starring this funny chicken. The head and body are made from the type of foam balls that florists use for arranging dried flowers. You can buy them in some florist shops and department stores.

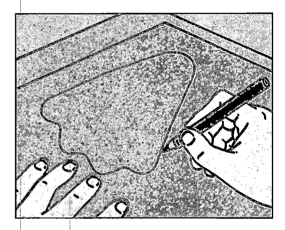

1 Paint the two foam balls yellow and let dry. Using a pencil, trace the foot pattern from page 44. Turn your tracing face down onto the orange cardboard and retrace over the outline. The shape will appear on the board. Cut this out and repeat to make a second foot.

SAFETY TIP: *Make sure an adult helps you when using sharp scissors.*

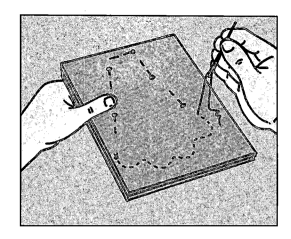

2 Place a board foot between two layers of felt. Pin the felt together, close to the edge of the board but not through it. Neatly sew all around the foot. Repeat for the other foot. Now cut each foot out, close to the stitching. (If you don't like sewing, you can glue the felt onto the cardboard.)

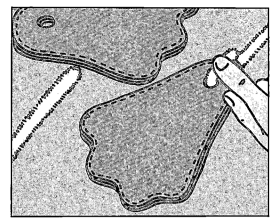

3 Punch holes in the back of each foot using a single hole punch. Cut the pipe cleaner in half to make the legs. Poke the ends of the legs through the holes in the feet and fold the ends over. Glue in place.

4 Break the wooden skewer in half and cover one end of each piece with glue. Push the glued ends into one foam ball. Apply glue to the other ends of the skewers and push on the other foam ball. Then poke the ends of the legs into one foam ball and glue in place. To make the beak, draw a 3½ inch circle onto orange card using a compass. Cut your circle out and snip into the center with scissors. Wrap the circle into a cone shape and glue the overlapping edge down.

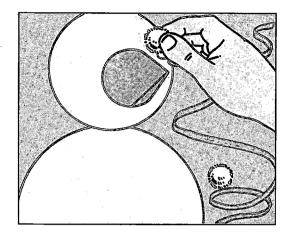

5 Glue the beak onto the chick's face. Then glue the pompons in place for the eyes. Poke the feathers into the chick's head and back. Finally, tie the ribbon around the chick's neck.

YOU WILL NEED

2 florists' dry foam balls,
 6 inches and 4½ inches across
2 pale blue pompons (or felt circles)
Orange felt, needle and thread
Yellow jumbo (chenille) pipe cleaner
About 25 red and yellow feathers
1 yard of narrow red ribbon
Wooden skewer and orange cardboard
Tracing paper and pencil
Compass and hole punch
Yellow paint and paintbrush
All-purpose glue and scissors.

21

SPEEDING ALONG

Make this colorful car out of paper to form part of your puppet show. You can either attach the stick to the bottom of the car, as we have here, or glue it to the side so you can push the car at high speed across the stage.

1 Using a pencil, trace all the pattern shapes from pages 45 and 46. Turn your tracing of the base shape face down onto some green cardboard and retrace over the outline. The shape will appear on the cardboard. Cut this out.

2 Retrace over the other shapes onto different colored board. Cut these shapes out also. You will need to cut out two sets of wheels.

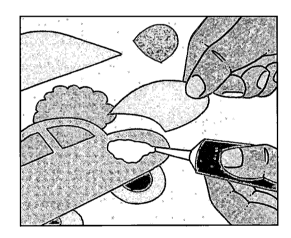

3 Glue the different shapes onto the green base board, one piece at a time. Start with the wheels, then stick the car body on top. Now add the front and back wings, and the headlight.

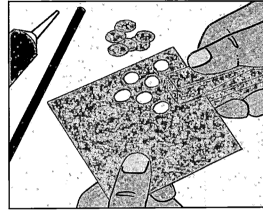

4 Use the hole punch to make small dots of board to stick on the car. Finally, glue the garden stick onto the back of the car.

YOU WILL NEED
Colored cardboard, including yellow and green
Garden stick
Tracing paper and pencil
All-purpose glue
Scissors
Hole punch

HENRY THE HORSE

Dance this colorful horse across your stage. He's great fun to make – use a toilet paper roll for the head and a wider piece of tubing for the body. We've used two thicknesses of rope, but one thickness will work just as well.

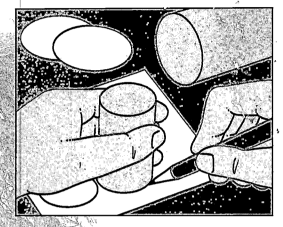

1 Cut a piece of wide cardboard tubing 5 inches long. Draw around one end twice onto thin cardboard and cut out both circles. Repeat with a 2½ inch piece of toilet paper roll. Cut these circles out.

2 Glue the four circles onto a piece of light orange felt and cut them out. Next cut a length of orange felt, making it as wide as the large tube, and long enough to wrap around it. Glue the felt onto the tube. Cover the small tube in the same way.

SAFETY TIP: *Make sure an adult helps you when using sharp scissors.*

24

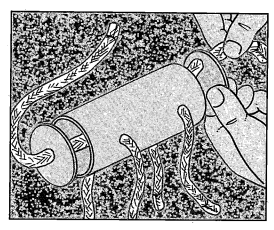

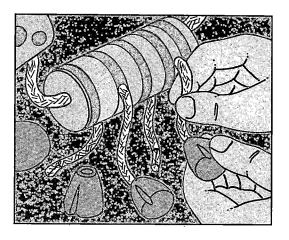

3 Ask an adult to make holes in the puppet pieces, as shown here, using a scissor blade. You will need eight holes in all: two in the small (head) tube, four in the large (body) tube, and one in each of the two large circles.

4 Cut two lengths of narrow rope 18 inches long, and feed them through the body holes to make the legs. Bind the ends with clear tape. Cut a 20 inch length of thick rope and push it through the body. Thread a large circle onto each end and glue the circles onto the body, positioning the tail hole at the top.

6 Decorate the horse with dark orange felt. Glue on blue pompons for eyes. Mold the clay into hoofs and glue in place. Finally, tie one end of the ribbon to the neck, attaching the bell. Tie the other end to the tail.

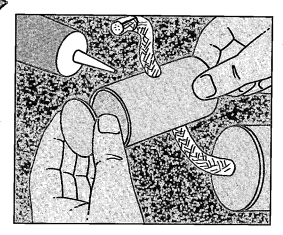

YOU WILL NEED

Toilet paper roll and wider cardboard
 tubing
Thin cardboard
Rope in two thicknesses
2 light orange and 1 dark orange felt
 squares
Orange modeling clay
2 blue pompons (or felt circles)
10 inches of narrow orange ribbon
Pencil and scissors
Clear tape
All-purpose glue

5 Thread the neck rope through the two holes in the head. Then glue the rope in place at each of the eight holes. Next, glue the felt circles onto the head. Unravel the rope ends for the mane and tail.

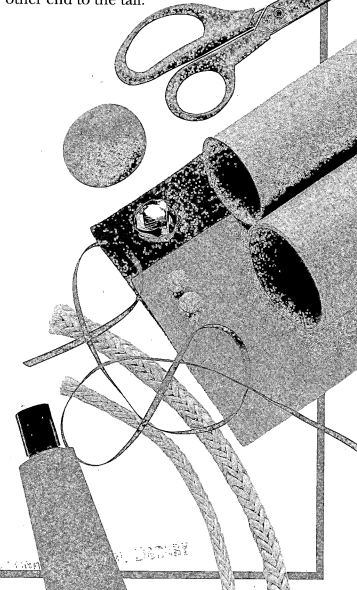

THEATER ROYAL

See how easy it is to turn an old cardboard box into a beautiful puppet theater. You can copy the stage front shown below, or you can make up your own design. If you want to use your stage for hand puppets, balance it between two chairs.

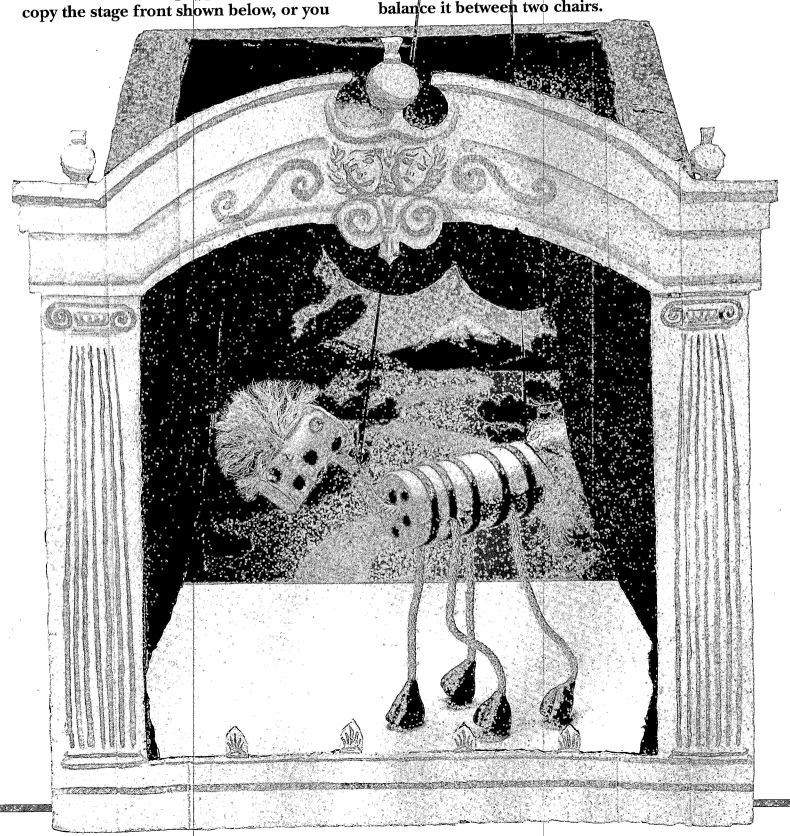

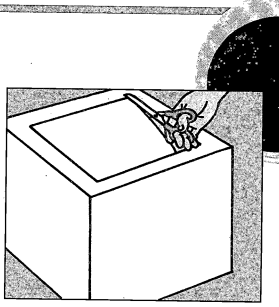

1 Cut away any flaps at the top of the box. Now cut a hole in the base of the box, leaving a 2 inch border all around. If necessary, put tape onto the inside of the border to hold it in place.

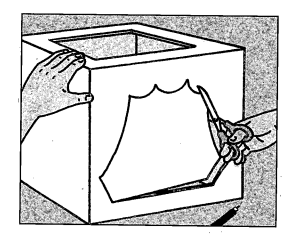

2 Using a felt-tip pen, draw a curtain shape onto one side of the box as shown. Cut the shape out with strong scissors – you may need to ask an adult to help you to do this if the cardboard is too stiff.

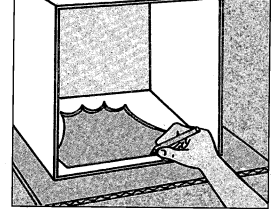

3 To make the stage front, take a piece of cardboard that is larger than the side of your box. Lay the box on the board, "curtains" down, and trace around the outside of the box. Now trace around the curtain outline, as shown.

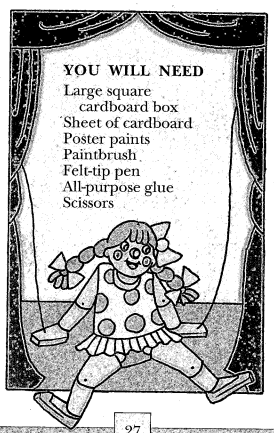

YOU WILL NEED

Large square
 cardboard box
Sheet of cardboard
Poster paints
Paintbrush
Felt-tip pen
All-purpose glue
Scissors

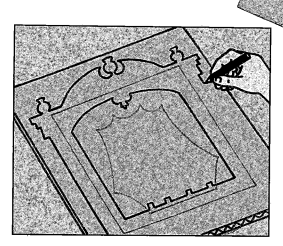

4 Using your trace as a guide, draw an outline for the columns and arch on the cardboard. Cut out the stage front.

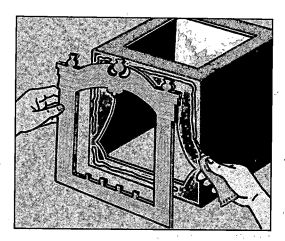

5 Paint the outside and inner sides of the stage black. Paint the curtains red, and decorate the columns and arch in yellow and brown. Paint a nice scene on the back of the stage. To finish, glue the columns and arch onto the front of the stage.

WOODLAND FAIRIES

You only need the simplest sewing skills to make these dainty fairy puppets. If you can't find any paper balls for the heads, try making your own out of papier-mâché pulp. Once you have made your fairies, why not make a fairyland stage out of an old shoe box (see pages 30–31)?

1 To make the wings, cut a piece of wire 20 inches long. Twist it into a figure eight, wrap the ends together around the middle, and bend the two loops upward.

2 Cut two pieces of net, about 14 inches square. Fold each square in half, then half again. Sandwich the wire wings between the net and pin together. Sew the net together around the wire as shown. Then trim away the extra net, being careful not to cut into your stitching.

SAFETY TIP: *Make sure an adult helps you when using wire.*

3 Trace the body pattern. Turn the tracing over onto your colored board and retrace over the outline. The shape will appear on the board. Cut this out. Wrap the body into a cone shape and glue the overlapping edges together. Snip around the bottom with scissors to make a zigzag hem.

4 Fold the pipe cleaner into a V-shape and glue inside the body for the legs. Fold the ends up for feet and decorate with small pompons. Glue the wings onto the back of the fairy, and decorate with more pompons.

6 Paint the fairy's face with felt-tip pens, and stick gold stars onto her dress. Finally, cut a 10 inch length of wire and thread one end through the back of the wings. Loop the end over to secure.

5 Glue the head onto the top of the body, then stick some hair on top. To make the crown, cut a small piece of board about 1 inch × 2 inches. Cut a zigzag edge along one side and roll the board into a tube. Glue together, then stick onto the fairy's head.

YOU WILL NEED
(For each fairy)
1 inch across pressed paper ball
10 small pompons for the wings and two for the feet
1 tiny pink pompon for the nose
1 white pipe cleaner
Scraps of net
White synthetic hair (or white yarn)
Fine wire and colored cardboard
Small gold stars
Pink and blue felt-tip pens
Tracing paper and pencil
Needle, pins, and thread
All-purpose glue and scissors

FAIRY THEATER

An old shoe box converts into the perfect puppet stage. Decorate the insides as we have here, and put on a play featuring the Woodland Fairies on page 28, or make up your own set. You can use all sorts of materials to set the scene – let your imagination run free.

1 Draw a tree shape onto each end of the box and cut the shapes out. You may need to ask an adult to help you cut them out if you find it difficult.

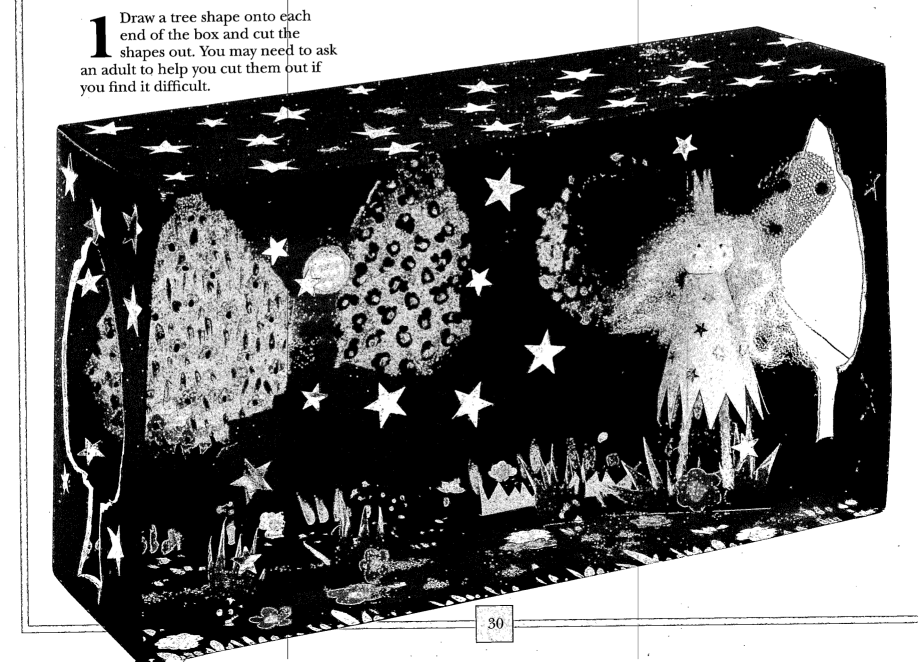

YOU WILL NEED

Large shoe box
Different colored cardboard
Poster paints
Paintbrush
Gold and silver stars
Different colored glitter
Glue stick
Felt-tip pen
Scissors

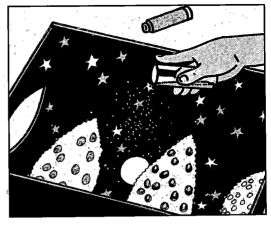

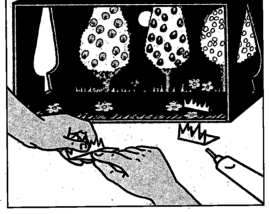

5 Finally, draw lightly with the glue stick on the back and on the floor of the stage. Sprinkle the glitter lightly over the glue so that it sticks to it. Shake the excess glitter onto some spare paper and save it.

3 Using your colored board, cut out some grass shapes. Fold the bottom edges back and glue them onto the floor of your stage. Now cut out some flowers and toadstools in colored cardboard and stick these in place as well.

2 Paint the outside of the box in a bright color. Let dry. Now draw some trees and a moon on the inside of the box. Paint the inside in bright colors, adding details such as clouds and grass.

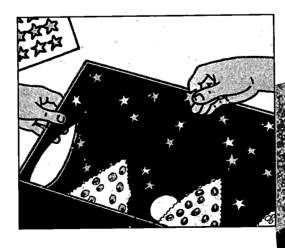

4 Decorate the stage inside and out by sticking gold and silver stars all over it.

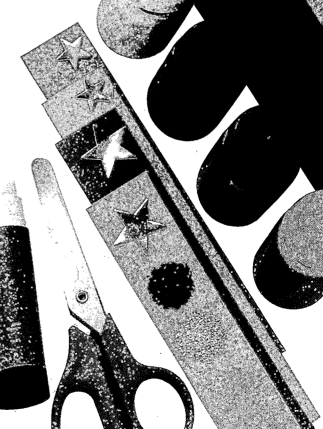

MA AND PA STICKETT...

Make these delightful cone-shaped puppets for your new play. If you prefer, you can make the heads out of papier mâché pulp instead of using pressed paper balls. And when you've made the whole family, you can make a stage from an old cardboard box – we show you how on pages 26–27.

how on pages 26–27.

YOU WILL NEED

(For each puppet):
Craft plastic
Pressed paper ball,
 2 inches across
2 white pipe cleaners
Scraps of red, pink,
 and beige felt
17 inches of thin
 wooden dowel
Selection of colored
 pompons
Pair of small joggle eyes
Tracing paper and pencil
All-purpose glue
Ball-point pen
Scissors

(see next page.)

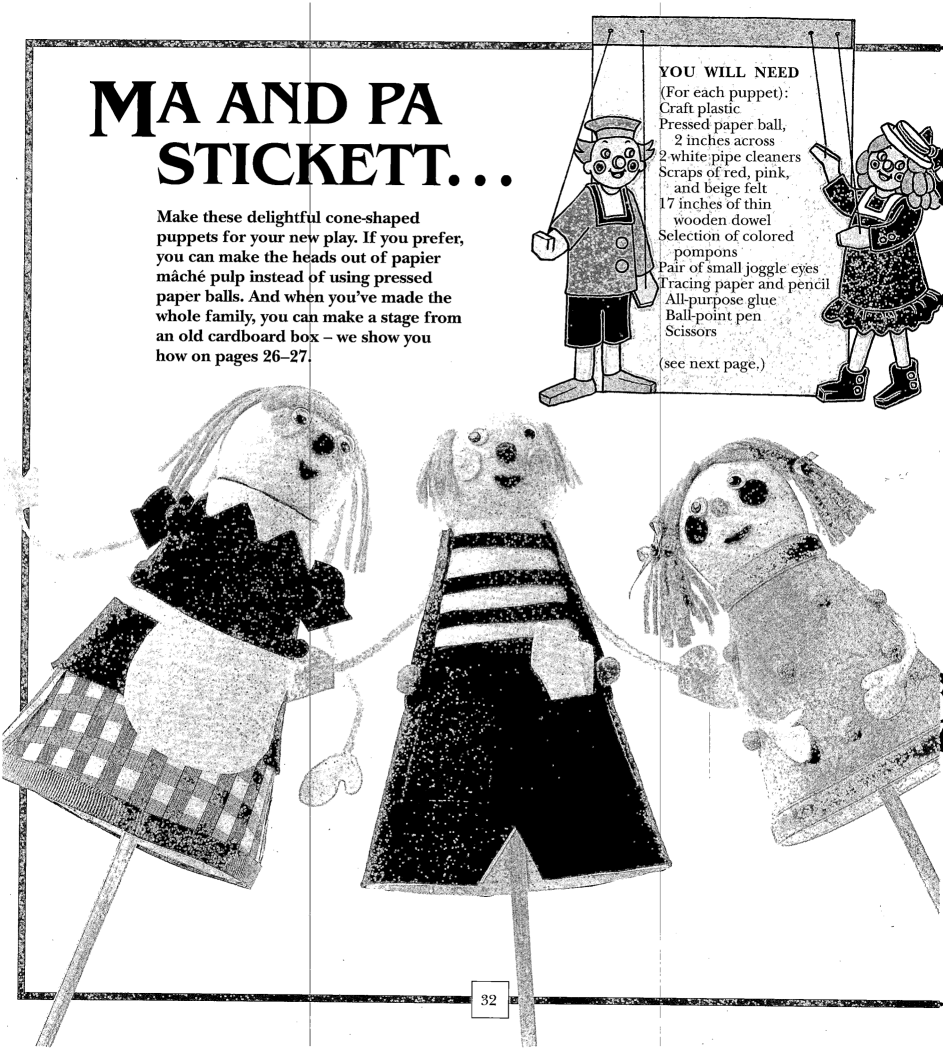

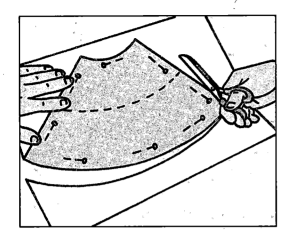

1 To make Pa, trace the body pattern from page 46, including the dotted line. Cut out the pattern and pin it onto some craft plastic. Cut out the shape.

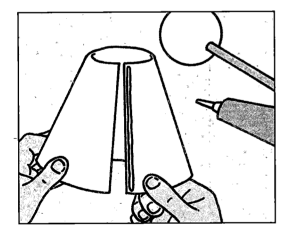

2 For the head, poke a hole in the paper ball using an old ball-point pen. Drop glue into the hole and push the ball onto the wooden dowel. Wrap the plastic body into a cone shape and glue the overlapping edges together. Now thread the stick through the body, and glue the body onto the ball.

(For Ma):
Square of red felt
Piece of gingham fabric
Scraps of white felt
Scrap of white cardboard
Narrow ribbon

(For Pa):
Square of white felt
Square of blue felt
Scraps of red felt

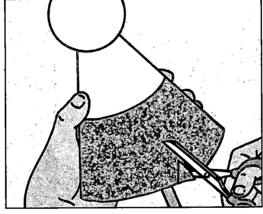

3 Use your pattern to cut a body from white felt. Glue the felt onto the plastic body. Now cut around the dotted line on the body pattern. Pin the bottom half of the pattern onto blue felt and cut this out. Glue the blue felt onto Pa's body to make his trousers. Snip a V-shape in the front of the hem.

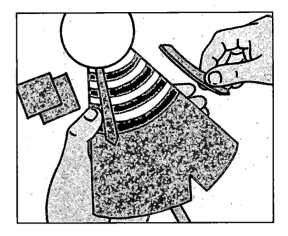

4 Draw two hand shapes onto pink felt with a ball-point pen – just copy the shapes freehand from page 46. Cut out the hands. Now cut two small square pockets and some suspenders from blue felt. Also cut long strips of red felt and a white felt handkerchief. Glue the red stripes, the pockets, and the suspenders onto the puppet. (Continued on the next page.)

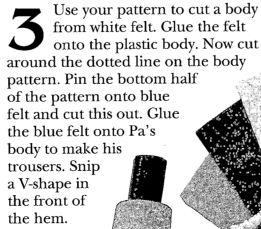

... AND THEIR DAUGHTER ROSIE

5 Cut the pipe cleaners into 3½ inch pieces and glue to the sides of the body for the arms. Stick the hands on the end. Cut a strip of beige felt for the hair, about 3¼ inches × ⅝ inch. Snip into it to make a fringe and glue onto the head.

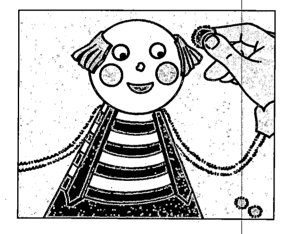

6 Cut a small red mouth and pink cheeks from felt and glue onto the face. Stick joggle eyes and a red pompon nose in position. Finish off with blue pompons on the ends of the suspenders.

7 To make Ma, follow steps 1 and 2. Then cut a body shape out of the gingham fabric. Glue this onto the body. Trace the pattern from page 46 for Ma's top. Cut the pattern out and pin it onto red felt. Cut out the felt top and glue it onto Ma's body.

8 Trace the patterns for the collar, sleeves, and apron from page 47. Turn the tracing face down onto white board and retrace over the outlines. Cut out all the cardboard shapes. Draw around the apron and collar shapes onto white felt using a ball-point pen. Glue both sleeves onto red felt. Now cut out all the shapes.

9 Cut the pipe cleaners into 3½ inch lengths and glue them onto the back of the sleeves. Cut out two pink hands as before and stick them onto the end of the arms. Glue the sleeves onto Ma's body. Glue the collar around the neck and a strip of narrow ribbon around the hem of Ma's dress.

YOU WILL NEED

(For Rosie):
Square of orange felt
Pink velvet ribbon
Narrow green ribbon

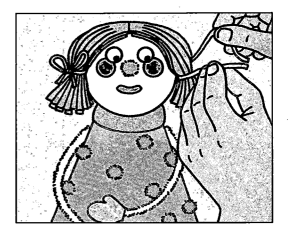

12 Make the daughter in the same way as Ma and Pa, using the pattern for Ma's top on page 46 for the body. For her hair, cut four pieces of beige felt, 3 inches × 1½ inches, and snip into them as before. Glue two layers of hair onto the head and tie the hair into bunches with narrow ribbon.

10 Cut apron strings from white felt and glue the apron onto Ma's body. Cut two pieces of beige felt 3 inches × 1½ inches. Snip into both pieces along one side and glue onto the head for hair. Now cut a small fringe to stick onto Ma's forehead.

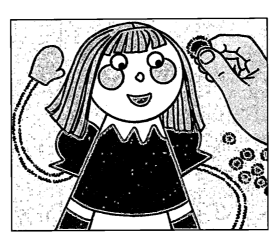

11 Cut out felt cheeks and a mouth and glue onto Ma's face, along with joggle eyes and a pompon nose. Finally, decorate her dress with red pompons.

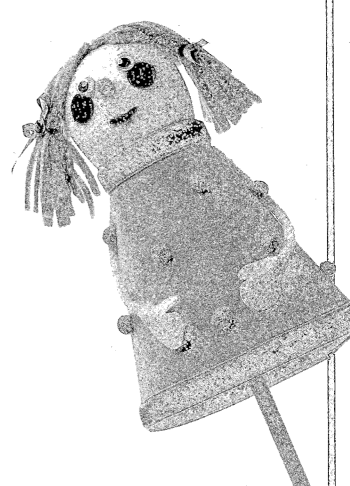

PATTERNS

You will need to use a pattern when making some of the projects in this book. The patterns on the following pages are all full-size. Read page 5 to find out how to use them.

FUN FINGER PUPPETS
Page **6**

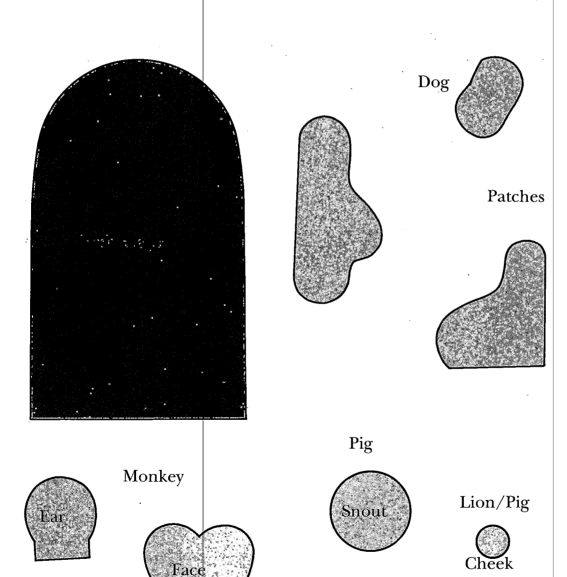

Dog

Patches

Pig

Lion/Pig

Monkey

Ear

Face

Pig

Snout

Cheek

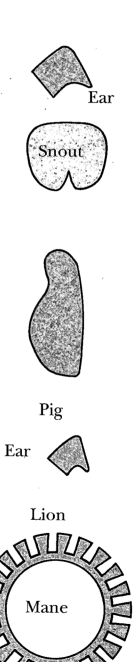

Ear

Snout

Pig

Ear

Lion

Mane

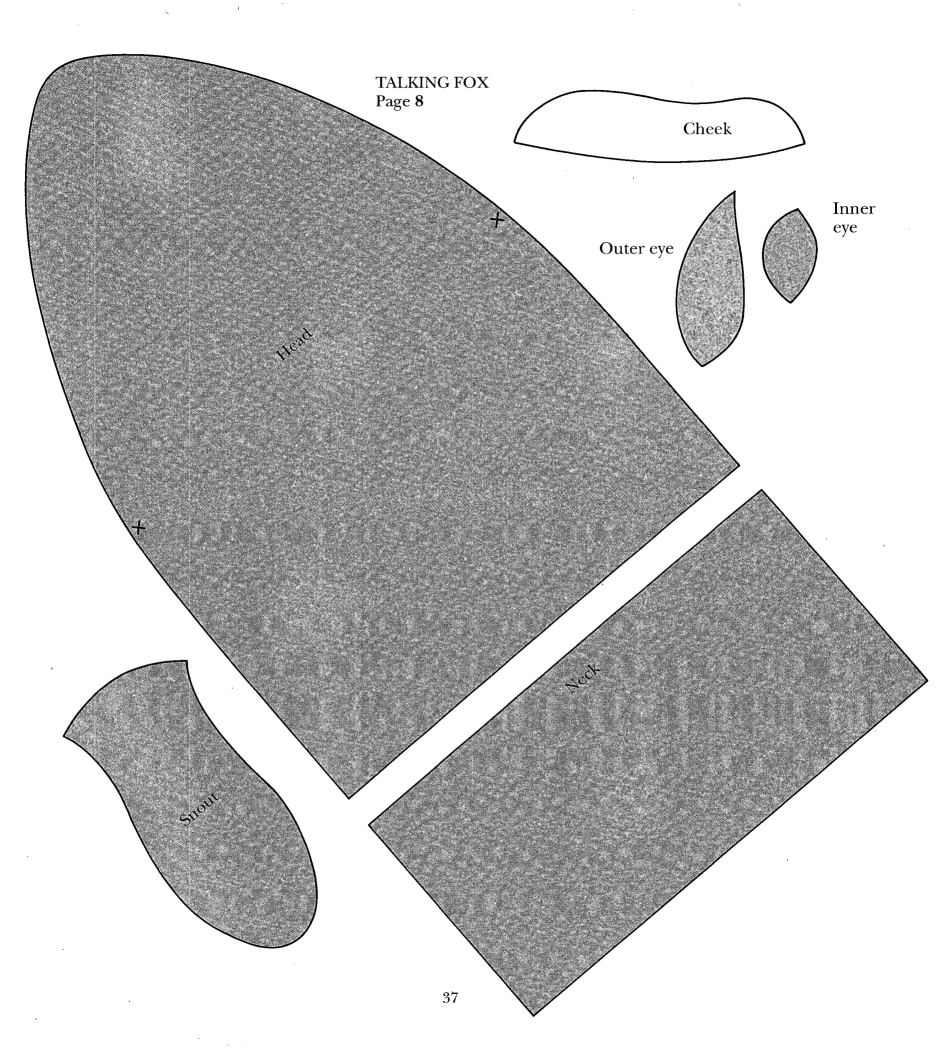

TALKING FOX
Page **8**

Cheek

Outer eye

Inner
eye

Head

Neck

Snout

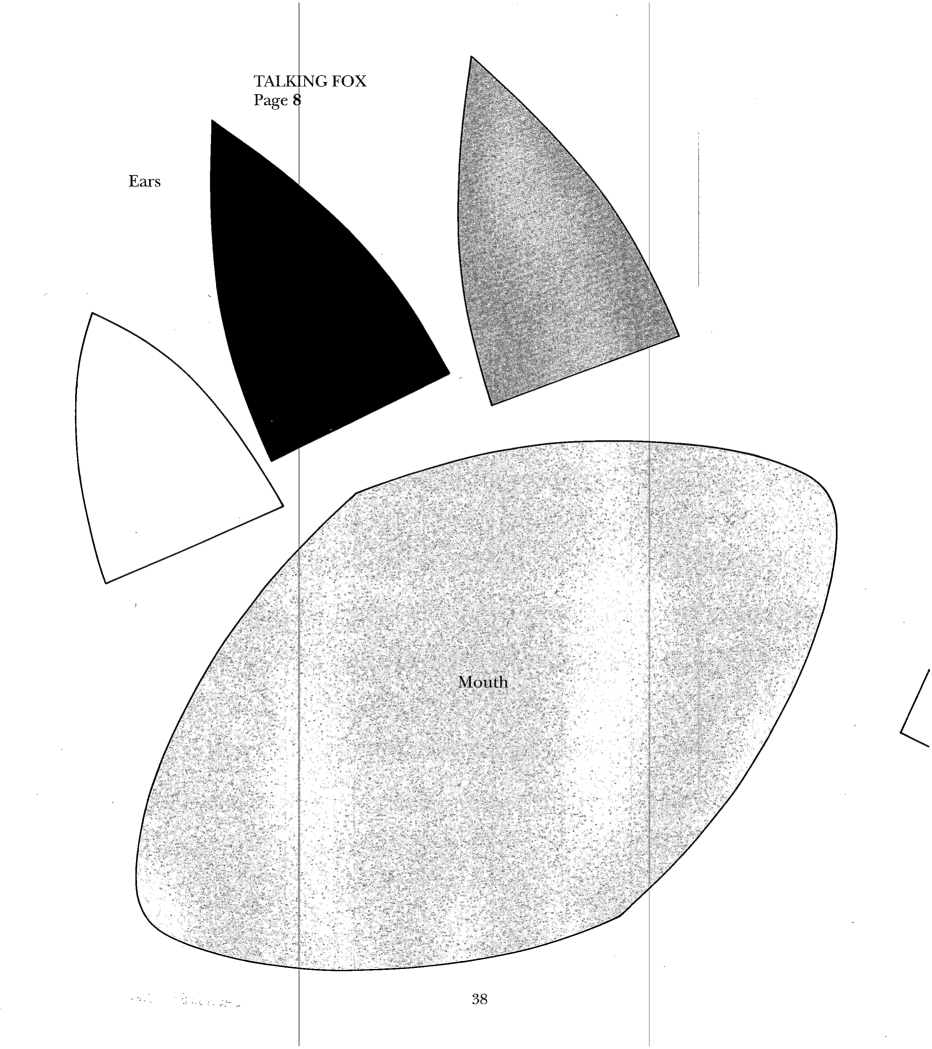

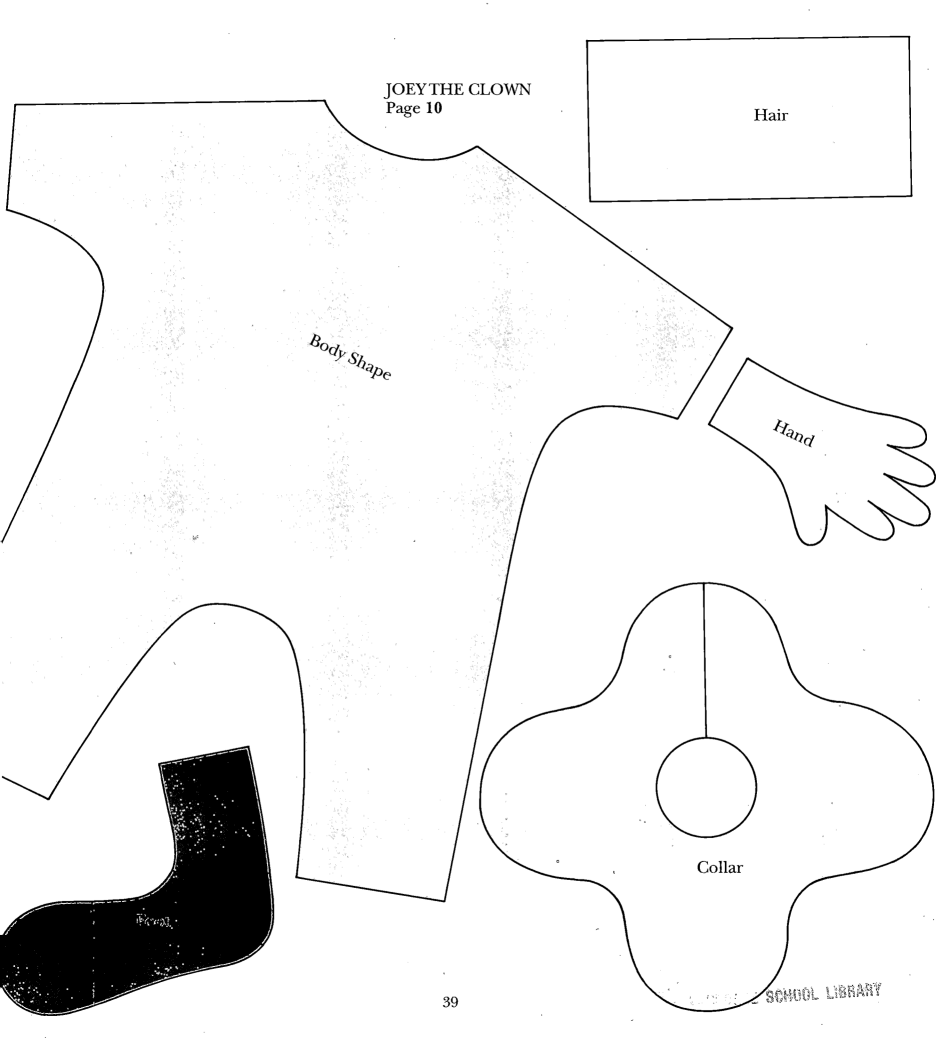

JOEY THE CLOWN
Page **10**

Hair

Body Shape

Hand

Collar

39

SCHOOL LIBRARY

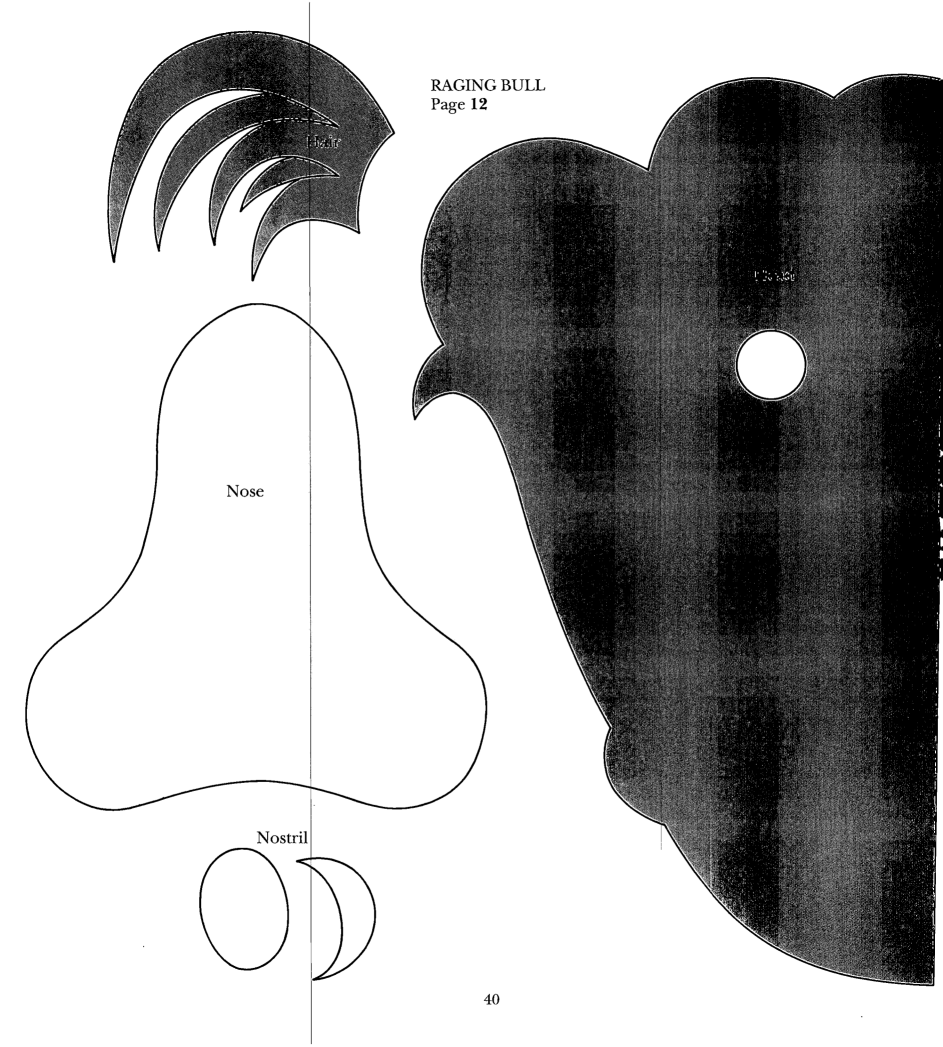

Hair

Nose

Nostril

40

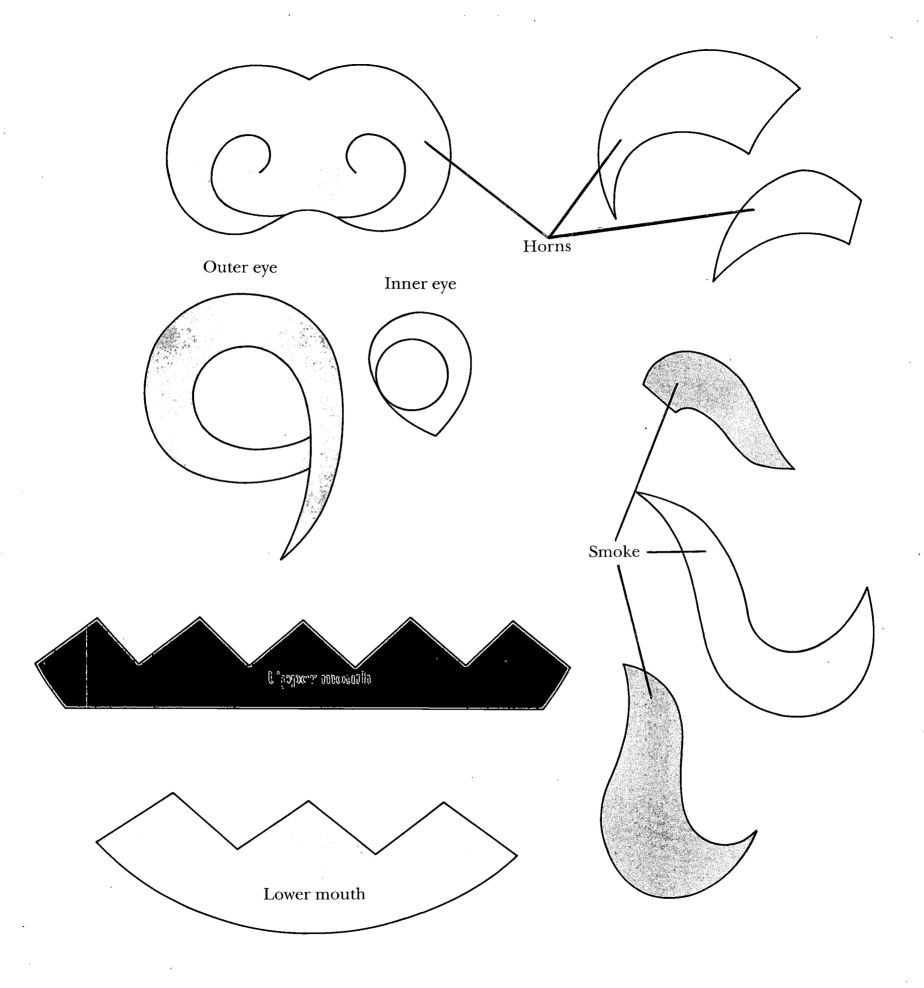

Outer eye

Inner eye

Horns

Smoke

Upper mouth

Lower mouth

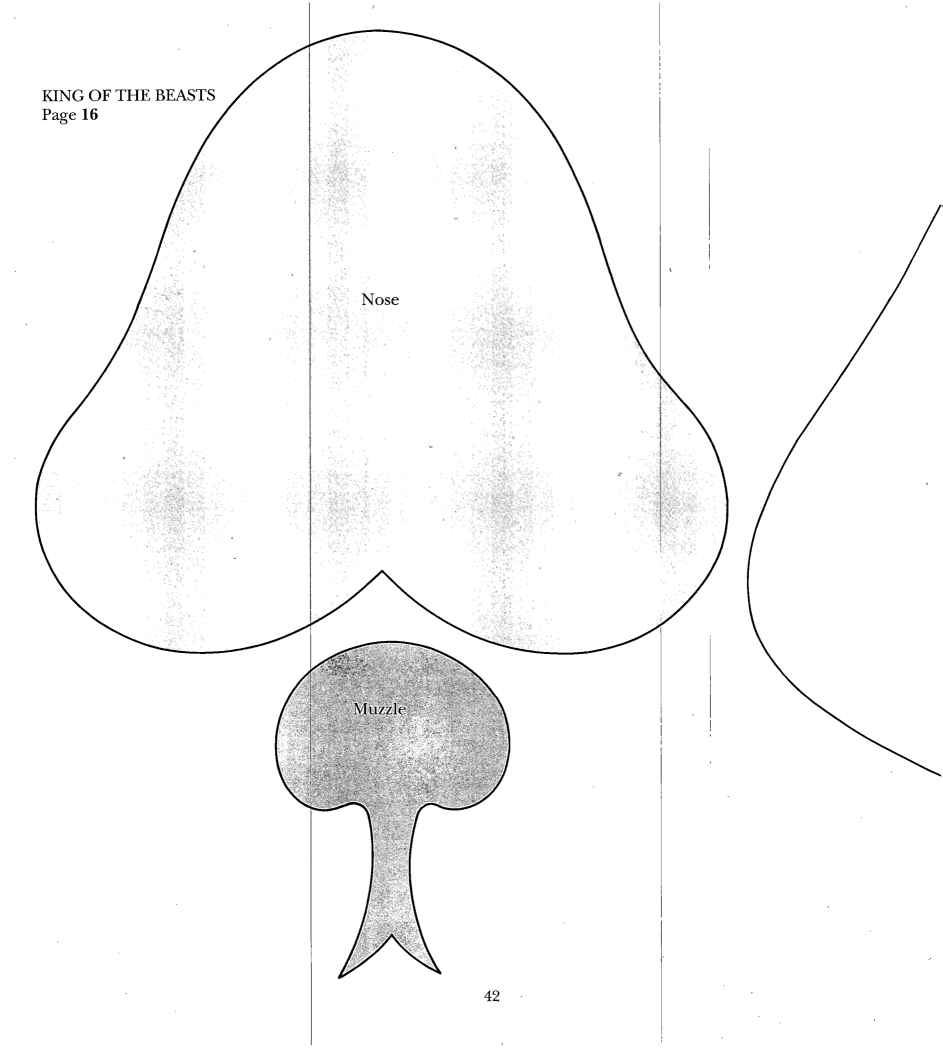

Nose

Muzzle

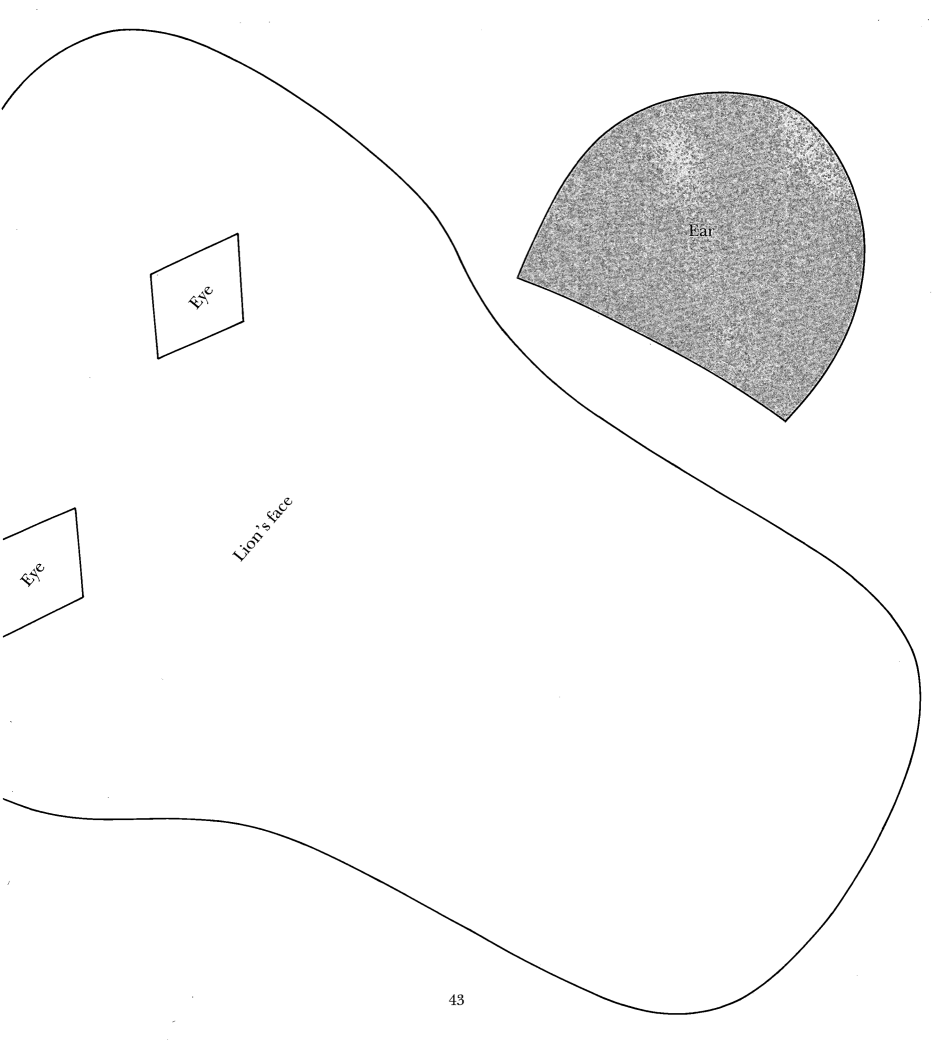

Eye

Eye

Lion's face

Ear

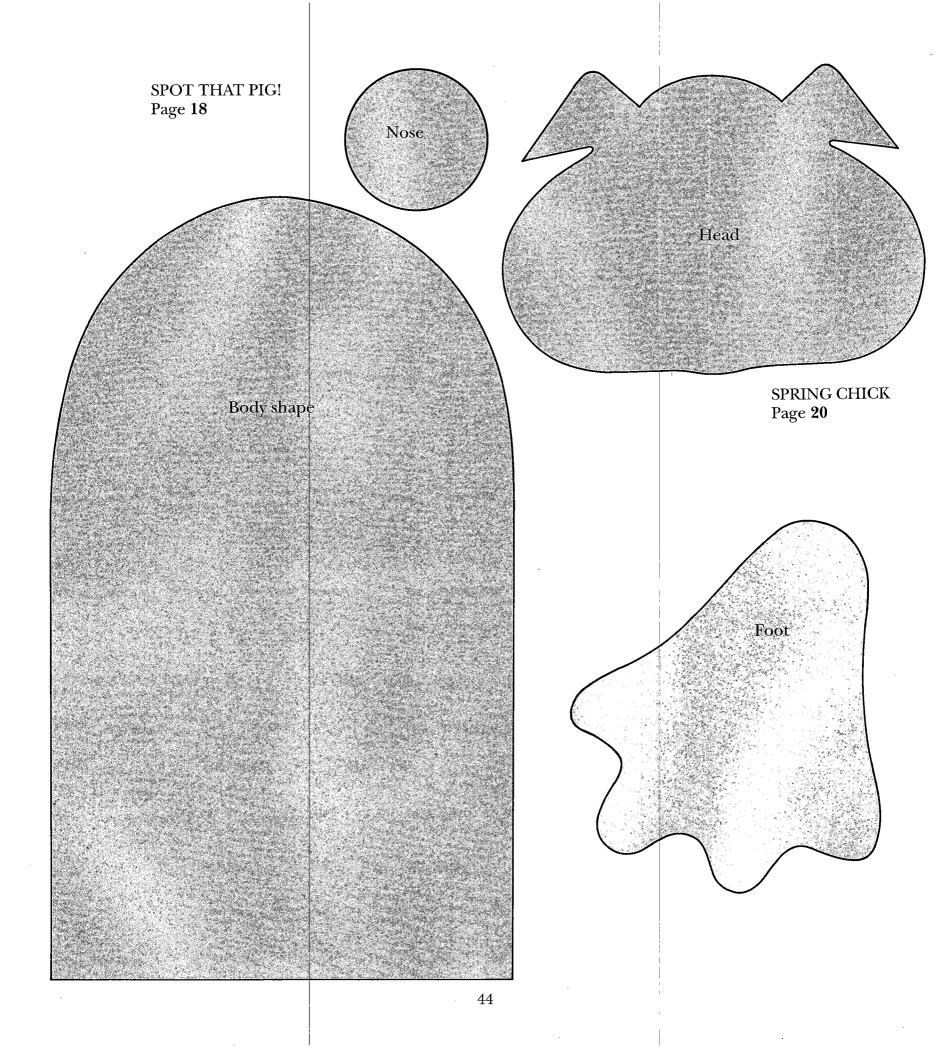

SPOT THAT PIG!
Page **18**

Nose

Head

SPRING CHICK
Page **20**

Body shape

Foot

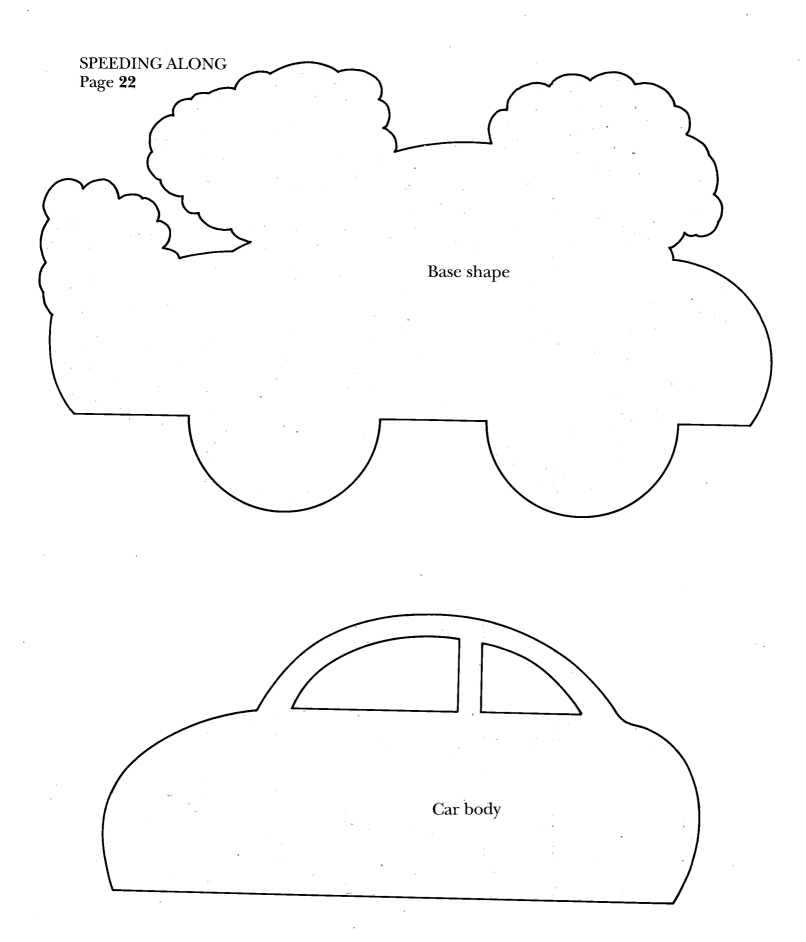

Base shape

Car body

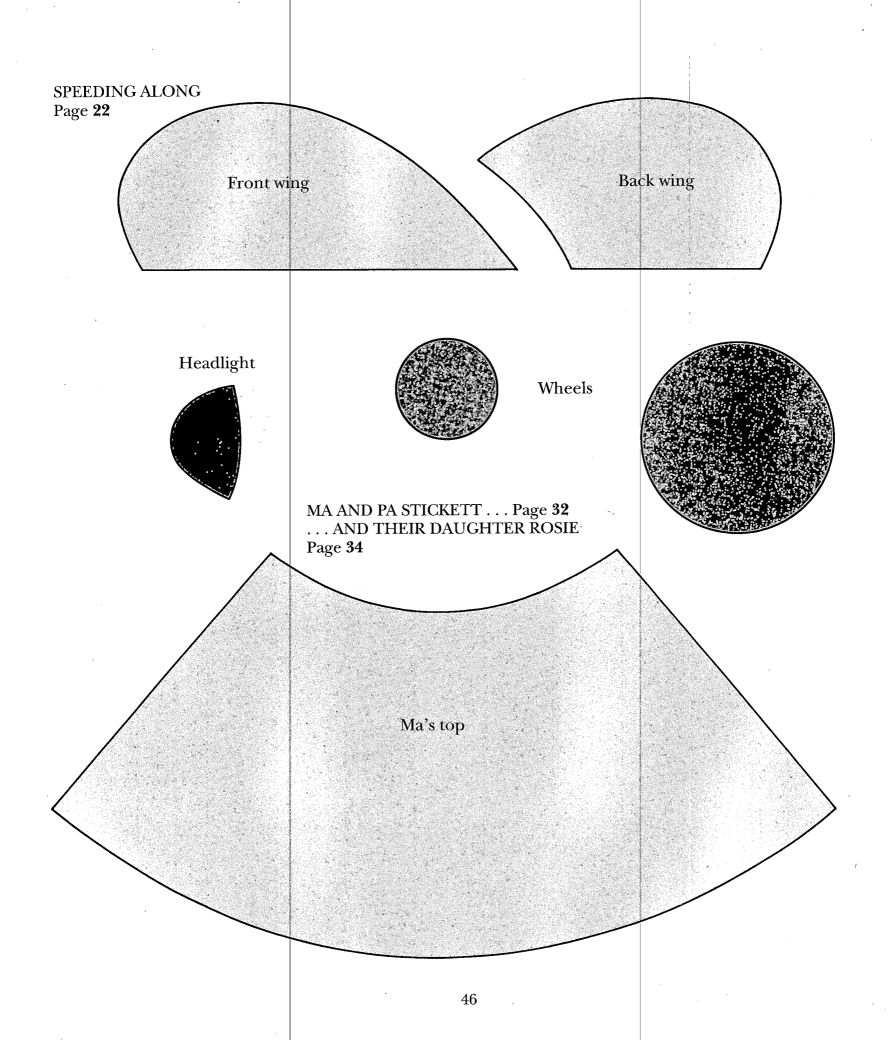

SPEEDING ALONG
Page **22**

Front wing

Back wing

Headlight

Wheels

MA AND PA STICKETT . . . Page **32**
. . . AND THEIR DAUGHTER ROSIE
Page **34**

Ma's top

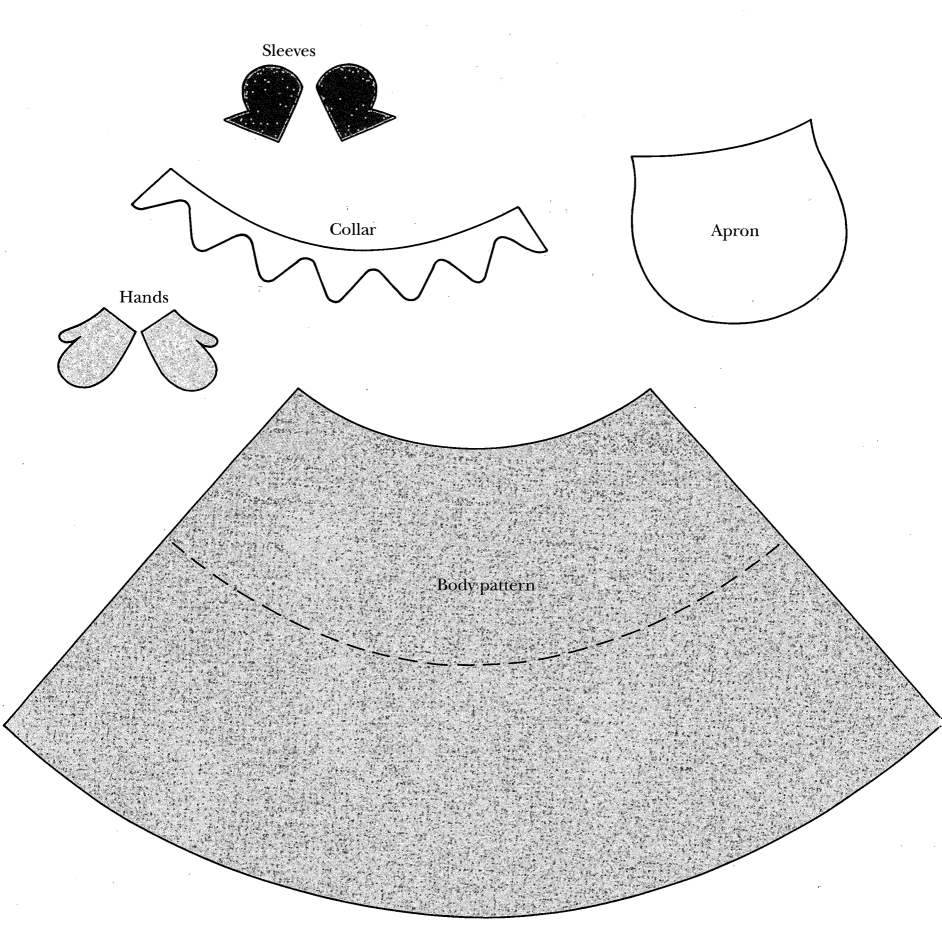

Sleeves

Collar

Apron

Hands

Body pattern

INDEX

ACKNOWLEDGMENTS
The author and publisher wish to thank the following for their help in supplying materials for this book:

Loretta's Crafts, 15 Sundown Avenue, Dunstable, Bedfordshire LU5 4AJ, United Kingdom.
John Lewis Partnership, Oxford Street, London W1.
Paperchase, 213 Tottenham Court Road, London W1P 9AF.